Scottish Borders

DANIEL GRAY

3 4144 0094 4838 8

This is Scotland is D... His first solo work, *Homage to Caledonia: Scotland and the Spanish Civil War* (Luath), was turned into a two-part television documentary for STV. His second, *Stramash: Tackling Scotland's Towns and Teams* (Luath), received widespread acclaim, with *The Herald* calling it 'A brilliant way to rediscover Scotland', which made getting lost in Cumbernauld while researching the book worthwhile. Gray's most recent work, *Hatters, Railwaymen and Knitters: Travels through England's Football Provinces*, was published by Bloomsbury and, according to *The New Statesman* is 'A delight'. An exiled Yorkshireman, he lives in Leith.

danielgraywriter.com
@d_gray_writer

...IE ...edie is the photographer behind *100 Weeks of Scotland*, a celebrated online project documenting all aspects of Scottish life in the two years before the independence referendum. It appears weekly via *The Scotsman* and is published as a book by Luath Press. McCredie has been a freelance photographer for a decade, working with most major agencies in Scotland and beyond. He has specialised in theatre and television but is perhaps best known for his documentary and travel photography. A member of the Document Britain photo collective, he is a Perthshire man lost to Leith.

alanmc.viewbook.com
@alanmccredie

D0533269

This is Scotland

A Country in Words and Pictures

Daniel Gray and Alan McCredie

Luath Press Limited

EDINBURGH

www.luath.co.uk

First published 2014

ISBN: 978-1-910021-59-0

The paper used in this book is recyclable. It is made
from low chlorine pulps produced in a low energy,
low emissions manner from renewable forests.

The publishers acknowledge the support of

towards the publication of this volume.

Typeset in 10.5 point Quadraat by 3btype.com

Printed and bound by
Charlesworth Press, Wakefield

Contents

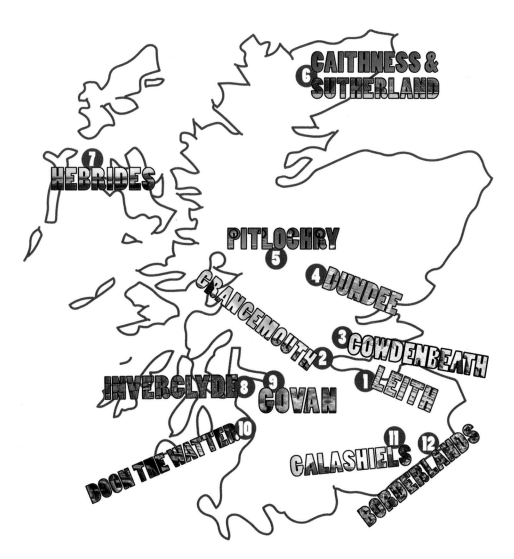

THE SCOTLAND WE SAW

Introduction

T his is not Scotland as the brochures display it. This is everyday Scotland
– not a nation seen wearing kilts or in the middle of eccentric rituals and
festivities but a nation of beautiful, haggard normality.

It is a place of Tuesday mornings at the bus station, not solstice ceilidhs or bagpipes by foggy lochs.

This Scotland is seen at a once-in-a-lifetime juncture, yet it could be any era: it is just that the clothes are different. While politicians and people with too much time to think became fixated with Ayes and Naws, this Scotland just went about things as usual. It always will. We wanted to see the normal moments it lived in and document them, to put on paper the daily grind you set your watch by, not annual and rare dates on a calendar. Something to look back on, something to read and realise in years to come that not much really changes when humans are around. Something to draw comfort from and smile with.

Our book does not claim to be exhaustive, academic or deep, but seeks to offer a fond glimpse of and a flirty glance at

Scotland. This country is quick and right to celebrate its lochs, hills and glens. Yet we think there is romance too in the run-down town and the battered old pub, and poetry in urban decay. It is chips in the rain with your arms around someone you've just met and want to kiss, not haggis and forced dancing with businessmen on Burns Night.

Further, there is more fascination for us in a gaggle of pensioners sucking on smokes outside the bingo than in epic Highland moonscapes. This is Scotland seen not with an itinerary or through an internet search, but via an aimless bimble.

The words and pictures are meant to complement one another, each filling in gaps, but not so fully as to leave nothing to the imagination. Portions of overheard conversations add context and paint the air, social history and local tales speak of yesterdays well lived. These histories

remind us that it is very often the small, neglected places which make a country, if not the world.

There was no rationale for our route, other than a vague feeling that the places in this book would contain sights and stories worth recording. We did not end up exploring the south west or north of Scotland as much as we would have liked, though that came down more to parental responsibilities than disinterest or unwillingness: this is no rock 'n' roll, Caledonian On the Road. In any case, we preferred trains where possible, and even a paddle steamer.

In our defence, Edwin Muir only travelled to half a dozen places for his Scottish Journey, probably the best travelogue about Scotland of the last 100 years. We too went to what is now called 'Inverclyde' and Dundee, though were slightly more generous in our offerings than Muir's conclusion that:

> Port Glasgow and Greenock comfortably stink and rot, two of the dirtiest and ugliest towns in Scotland, with a natural position second only to Dundee, which is the dirtiest and ugliest of all.

Muir's book is ingrained with a sadness about what he sees as a country in decline. It is one that is:

> ... gradually being emptied of its population, its spirit, its wealth, industry, art, intellect and innate character.

Before our meanderings began, it was not a Scotland either of us recognised, but then our own version could, we realised, be a false, or at least different, one. Leaving that version behind in Leith, in Grangemouth, Cowdenbeath and Pitlochry, Caithness, the Hebrides, Govan and elsewhere, we would seek to find out just who exactly Scotland is.

These places would also help us to present a non-homogeneous Scotland at a time when political discourse sought to stamp on the country a solid, corporate identity.

Across twelve areas we would look for a country, eat a lot of chip sandwiches and see more pebbledash walls than any person should. We wanted to capture everyday Scotland for every day to come, the view from the lens and the pen as it was in the second decade of the 21st century.

We hope this book sings you a song.

Leith

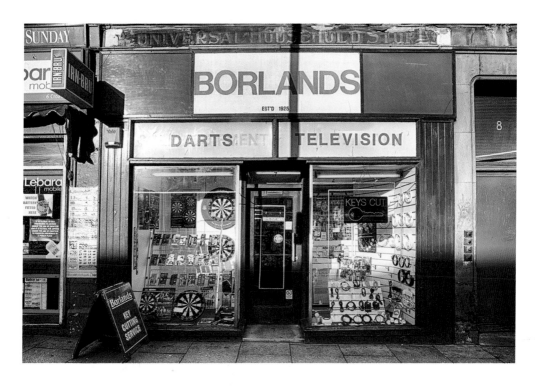

This street, this whooshing artery. For a mile it rolls, a river with tributaries of dirty-beach-coloured tenements. Leith Walk, or 'The Walk' if you're from these parts, is not a street but a documentary.

Everything can be found here, just like the brochures say about other places. This is a different kind of everything. It is shops that repair televisions and sell dartboards, and shops displaying vegetables of which white people will never know the names. It is the old boy in a kilt asking of you pence for a brew. It is the young girl in oversized glasses on her way to talk about design specs in a bar that will never sell Tennent's lager. It is dog muck on your feet if you're not careful, and a smile from someone handsome if you're good.

Life should be fast on Leith Walk, but somehow it's not. There is probably just too much to look at, too many people with stories on their faces. In Polish delis they stop to talk of home and add up the hours they've worked this week, more than there are on the clock. It helps that traffic obeys humanity: cars drive slowly because the people have their own crossing rules. Rushing and Highway Codes are for those up The Walk in Edinburgh. We are a 15-minute daunder from high teas and royal tattoos here, and the same council collects the bins. But to go to Edinburgh is to go 'up the big toon', and why would you ever do that: there's everything you need in Leith, you hear them say. They will never be from Edinburgh, they carry on, always from Leith. On borderland sits a pub called The City Limits. Early last century in a flat above, goes one legend in a land of legions, were born twins. The mother had one in the front room, making her from Edinburgh, and one in the backroom, making him a Leither. Back then being a Leither was not a state of mind but a status – this was officially a separate place.

Leith had its own happy blue electric streetlights and a tram network. Both came before slovenly Edinburgh caught up. This was Scotland's largest port town.

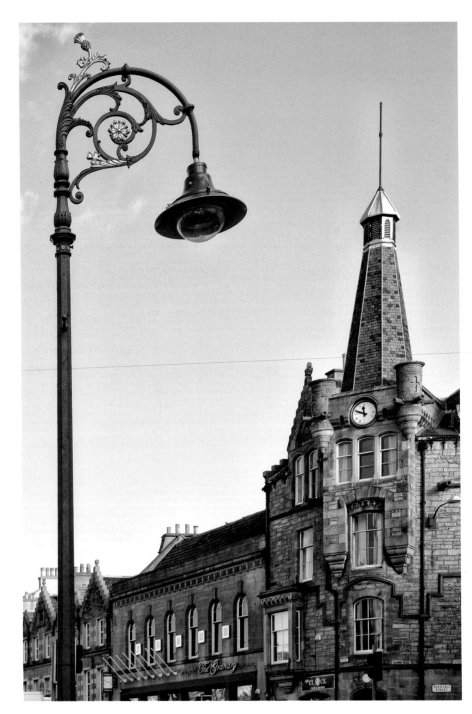

The revenues that generated collided with the local pride it bred. Leith advanced. It was no thunderbolt that, when offered the chance in 1920, Leithers voted resoundingly to remain independent of Edinburgh by a measure of 30,000 Naws to just 5,000 Ayes. 'That hated word, "Edinburgh'," the local paper called it. With the backing of Parliament, Edinburgh gulped them up regardless. It is fiction to say that no resentment lingers. This is subconscious rather than precise: there may be no teenagers burning copies of the Act which made the gulping possible, but there is a gnawing undercurrent that somehow, folk from up the big toon always lord it over Leith and always have it better. Leithers are ignored, but that is not necessarily a bad thing. It leaves room to get away with living, a garden to flower in.

The Walk comes to an end and the streets narrow and curve their ways to the water, becoming cobbled and wise. After them: sea and the rest of the world. They have names that tell old sailor's yarns, like Baltic, Cadiz and Elbe, and lead to moonscapes where once warehouses and shipbuilders were. Beautiful scars remain – cranes next to the casino, brass ship-tying posts as bulky as hippos that you trip over on your way back from the pub.

Those pubs were once for gentlemen of the sea and ladies of the night. At the Shore they piled forth in their hundreds with not only a few bob in their pockets; they were pleased to see Leith. Randy sailors were joined by rambunctious locals, and in every bar Go-Go Girls got things going. Their meeting places included Fairley's, home to a puma in a cage. Nothing is untrue about this tale, too many have told it and told it well. The cursed beast spent whole years in the 1970s beside the bar, lashing unhappily and understandably at anyone who tried to give kitty-kitty a stroke on their way to the condom machine in the gents.

When on out-of-hours exercise it mauled a Go-Go lass who had fallen asleep in the toilets, the authorities took it away, we hope for a better life. The Go-Go lass ended a beggar. Such is life in Leith: rumour and stories, colour and heartstrings. In those puma years of debauchery, time ticked ever slower on the docks. No man had a spare penny in his pocket, save for the few who still had a

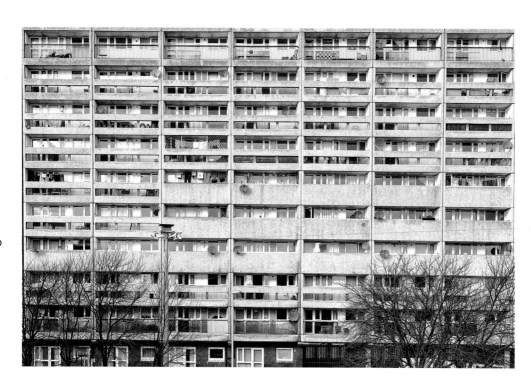

job. Even they were stopped in the 1980s. The shipyards went to sleep forever. Some families fled, some sat it out, some slipped into the mire. Their helplessness forged hopelessness in their sons and daughters. Drugs filled the gap. Some remain lost.

From somewhere Leith remembered its motto: Persevere. It sat in Formica cafés and masterplanned its way to Michelin-starred restaurants and cool jobs that necessitate beards. Incomers brought energy like the Italians had in the 1920s, then later the Afro-Caribbeans and the Asians. Now they were Polish or Lithuanian, and from the rest of Scotland too. Even England. Even bloody Edinburgh. The genius is that they did not completely bomb the past. The Formica remains and there are more wimmin that say 'ken' than Michelin men. Always will be. This is a land of buses, not mortgages. At the Mela festival and by the 'Banana Flats', up and down the Walk, Leith seems to be rubbing along nicely. It'll never have the money, but it'll always have the charm.

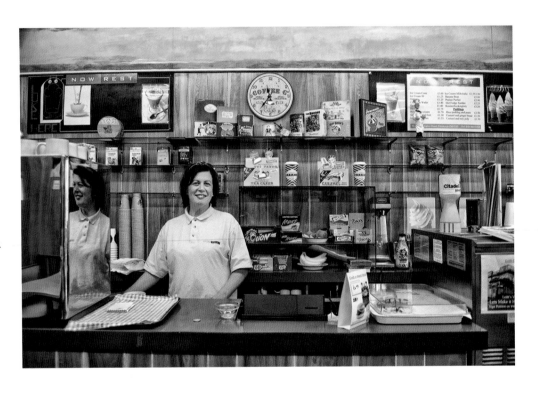

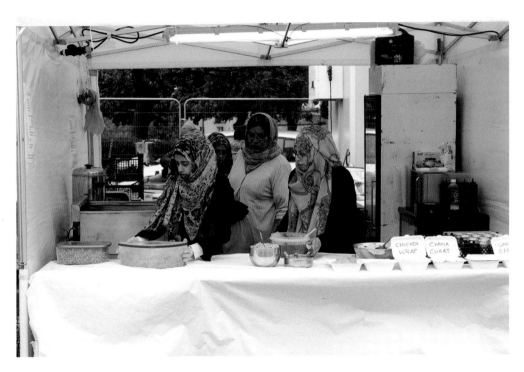

Grangemouth

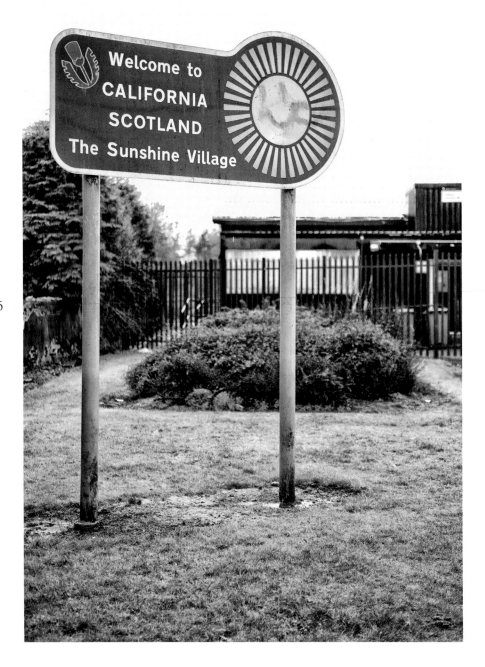

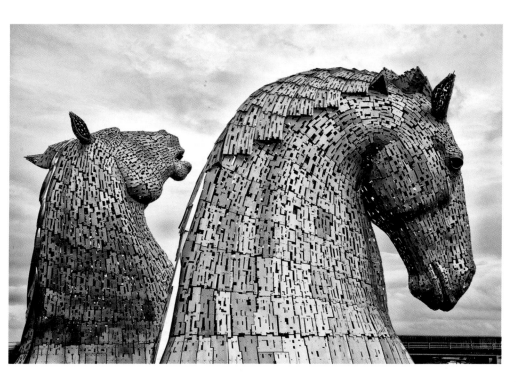

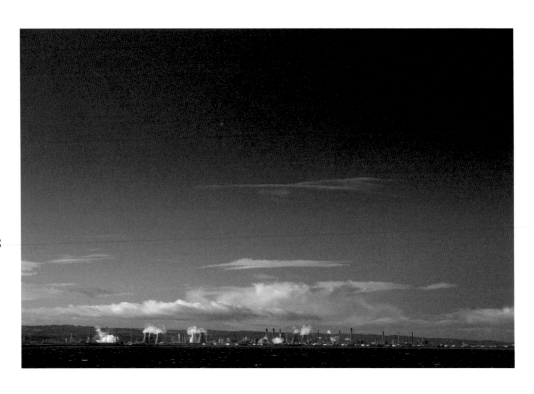

Drizzle shatters narrow roads and makes dirty rags of sheep. It blobs from holes in the guttering and twists among the pebbledash. Its mother sky is the colour of water infused with liquorice.

The hub is a Lifestyle Express newsagent-cum-crisps-emporium, and a bus stop out of here. By the community centre is a half burnt-out caravan whose teak units carry pornographic pages torn from magazines. It can only be California, California near Falkirk.

What chutzpah – Yiddish for 'gallus' – to name a pit village after the sunshine state. One hundred and fifty years back, they looked across the pond to gold in those there hills and decried themselves, as discoverers of black diamonds beneath the soil, the same. There must still be a pride today when these Californians read their address to the call centre operative, still be residents who with patient joy smile through the words 'not the one in America, unfortunately!' The double-breasted caravan is an aberration, for this is a tidy, working-class village of strong houses and stronger families.

All have one foot in the thistle – walk five minutes in any direction and you will find countryside of a hundred hues. There are dark green trees, dusty straw grasses and Mars-coloured fields. Hills rock and roll until the eye gets sick of them, an eye which sometimes weeps for what was, for here lay coal and work, hard and brutal. This face of Scotland says: we built the world, now someone else's sons do.

It is not the only face. Horses with necks as strong as mountains trawled the soils near here. They pulled the barges and allowed an Empire to build wealth on their concrete backs. Horses like Camera, 19-hands high and the biggest worker nag in the world.

How they have been marked now, justice done to these shapely titans in the form of giant steely Gods between motorway and canal. With each step towards the Kelpies, their magnificence

29

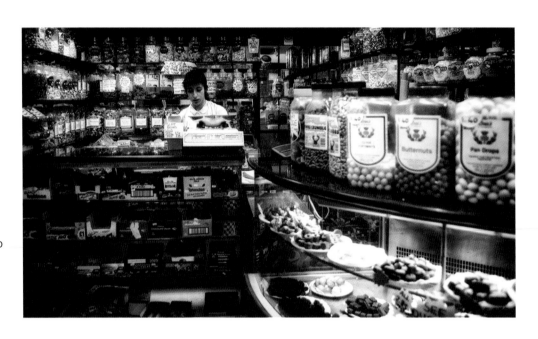

and nonchalance hits your heart that little bit more until it beats like the rhythm of a Falkirk-built diesel bus doing 70. The monotony of the motorway chorus is a cruel joke next to their smooth gallantry, and drivers must try hard not to become part of the joke by crashing while gawping.

It would not be their fault: anyone who sees the Kelpies should turn into a lovestruck teenager. This is a monument, yes, but it is a sign of confidence, a cultural investment in recognising the past, but also one of pound notes to remind us that there is a present and a future in Scotland. They still build those buses within a nostril-breath of the Kelpies, and in the other direction sprawls Grangemouth. Scotland is a not a museum.

A black motorway sign denotes 'Grangemouth Industry' and twists and turns lead to a belching panorama. The rain has retreated for now into a surprising blue sky which is being burnt at by chimneys, birthday candles trying to singe the lampshades. Their smoke is blown horizontal by bluster from the Forth. If ever the fires go out, the only wish will be for their relighting. Jobs like those here matter far beyond the tea van at the factory gates.

Grangemouth stands ahead of us, a stretched Emerald City of flues and cooling towers. The air is dashed with the scents of rust and bonfire nights, denoting chemical processes we will never understand, and men with jobs we can only nod our heads at and smile politely. There is alchemy in this place, conjuring tricks inside and out. You don't have to understand beauty to see it.

Here is not just fire and fury. Underneath the smoke is a town.

It has its mossy war memorial and bonny park like any other, its people chatting on corners and laughing through the mizzle.

'That's the rain back on, son,' says a lady near the old Empire Electric Theatre. 'Lovely day,' we reply. 'It is,' she carries on, 'bloody gorgeous. Ah might have a wee dance.'

The town has a certain jolliness, wit in adversity perhaps. Its 1960s precinct centre does not look ugly like it should: more like a toy town model found in the loft and still in good nick. There are butchers, bakers and candlestick sellers.

31

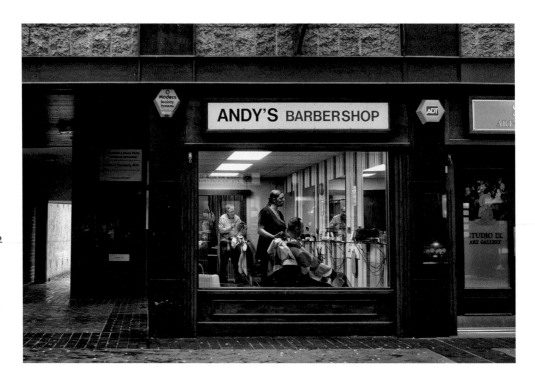

Golden light from behind steamed-up windows and the comforting stench of chips denotes La Gondola, a heaven of deep fried things and hard-boiled confectionery. Most Scottish sweets are more intense than their English cousins. Brighter, harder and with names like Soor Plooms, they seem to punish the mouth – Presbyterian delights. There is nothing gummy in sight. Striped red paper bags must be made to work hard.

This high street does not buzz or bustle, but it does tootle on agreeably. Shops are never packed, but till drawers sound every few minutes and, more importantly it seems, each customer spends a while completing the real transaction: gossip.

News of illness and injury, pregnancy and funeral arrangements are a social currency of worth. Here is a place undeterred by rain or hard times, or at least unwilling to look them in the eye. People busy themselves, getting jobs done even if many have none to go to.

When gossip temporarily halts and they fall silent, the older ones stare over the rims of their teacups and through Marlboro fogs to see another time. They can remember a Grangemouth of shipbuilding and soapmaking, of Dutchmen and Canadians passing through the port and sharpening many a night out. They look over those rims and see what was, but here is a Scotland which is and can be.

33

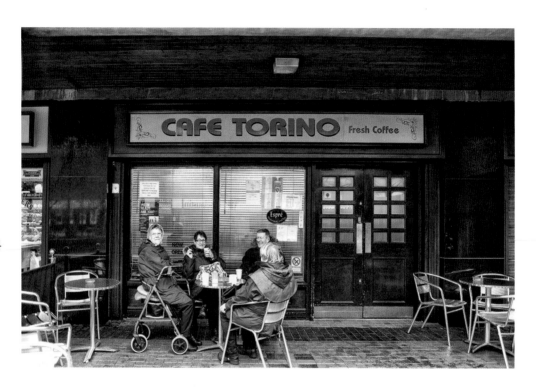

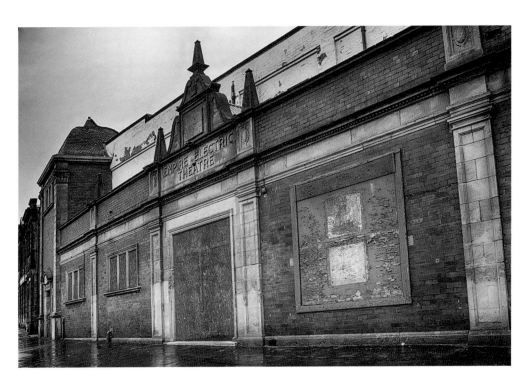

Cowdenbeath

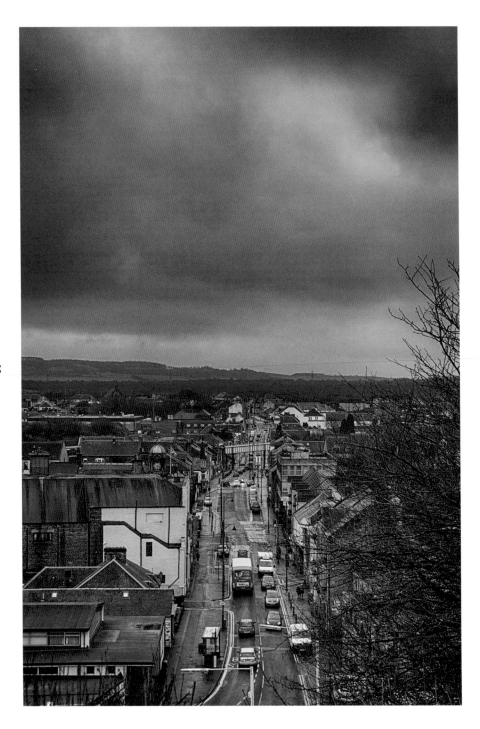

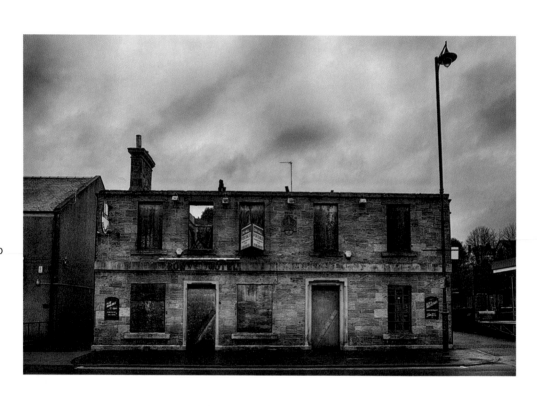

The Kincardine Bridge cajoles us into Fife, while the River Forth plays peekaboo, suddenly disappearing behind forests, hills and occasionally the groggy dwellings of pit villages.

The Kingdom is rarely thought of as playful, but there is charm in its flits from greenery to grit and ministers' manses to miners' cottages. This does not lead to an identity crisis, quite the opposite: there is something very sure and reassuring about Fife. Fifers had to be sure of themselves to make this area the blood-red heart of the world. Cowdenbeath was its epicentre, the wee town where they raised the scarlet standard from the town hall pole. Six days before a by-election in 2014 and you would think no-one had the vote – all lampposts are free from placards, and there is not a rosette-wearing bairn kisser in sight. After half an hour searching for signs, a 'Yes!' campervan splutters by, Big Country tinning out of its roof speaker. 1921 it is not.

1921, 1921, 1921. The wind here should whistle that year. 1921, when Soviet Cowdenbeath made the British Government shudder. For all of its short life, this town had been radical. Miners found solace from their dangerous lot in self-education and the politics of unity. They could quote Marx as well as they could snaffle eight pints. Their reputation incited French anarchists to set up a HQ in town. When 1921 came they were ready.

It all happened on a Spring night. Strike action turned to rioting when the miners found their managers staffing the collieries. Those managers were removed and paraded, spoils of war. Violence would not do: a public meeting was held instead. Their democracy did not stop rumours flying. Incendiary word reached London that Cowdenbeath miners were about to raid an armoury and declare their area a workers' Soviet satellite, the farthest reach of Moscow's empire.

The Cabinet sent in the troops. Cowdenbeath awoke to find itself under

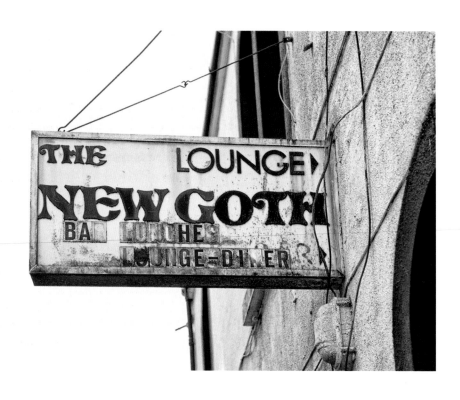

martial law. 'An armed camp', the *Dunfermline Press* called it. Scores were arrested and hoyed into jail singing 'The Red Flag'. The scarlet flame only ever simmered beneath.

In 1926, the British Communist Party's leader raced to Cowdenbeath to tell its miners to cool down: the rest of the country was not as ready for revolution as they were. This area elected the UK's first Communist MP, Willie Gallacher, and its first Communist provost. Even the authorities were at it, naming streets of council housing after Soviet heroes.

From above the town we see Cowdenbeath's long high street, and the way it is sinking. Here is a place whose guts have been mined hollow, first physically and then later by the forces that left the place for dead. No wonder politics don't appear too important to the hundreds who shuffle out of the bingo hall, or the hundreds more who stream towards the football ground, its floodlights a call to prayer. What today's locals have in common with yesterday's – and indeed many are yesterday's, having never left – is the need for pleasure. Not that much has changed.

Men trickle into The Goth as they have for over 100 years, their afternoon session occasionally lifted by the presence of a lesser spotted female. No-one can see into The Goth, and no-one can see out. The passer by misses dark oak innards, dusty barstools and framed photos of times departed; the denizen drinker misses the day march on, and why not? Besides, a half and a nip is cheap in here, the one-liners even cheaper. Stick 50p on the side of the pool table and you're anyone's friend. The Goth has never had see-through windows. It was opened as a rueful admission, a proverb that didn't catch on because it didn't need saying: give a man a wage and he will sink the bevvy.

There was never going to be abstinence in a town that worked so hard and dreamed of utopia, so a pub on 'Gothenburg principles' became the next best thing for those with influence, like priests and wives. A Goth pub would not be attractive to drink in – as dark as a mole's burrow and cold like a winter's night on the moon. It discouraged very few, and in any case

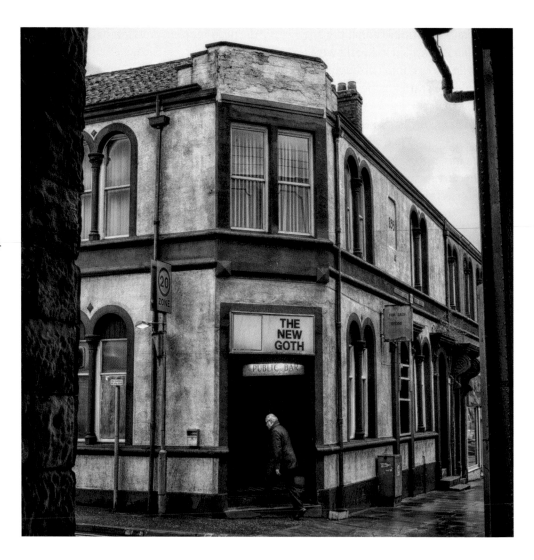

the drinkers were doing social good: all profits went to improving the town. The fact that they had a handsome park to stumble home through was all down to the drinkers.

There was ale and there was football, but here too shined magical, moving pictures. Every week outside the Crown Hotel, Joe Slora would park up his mobile cinema. A small town needs an eccentric or two – you have to look harder now – and old Joe was Cowdenbeath's. He made talkies before talkies were invented by standing at the side of the screen and improvising dialogue or sound effects. That was entertainment, entertainment way before the satellite dishes which pock the walls of every two-up and two-down up the hill in Lumphinnans. China did its bit too, helping the Saturday night in become not a sad chore but a tasty pastime of deep fried ambrosia. Green has uprooted black in the old coal valley beneath, and on the other side the Paps of Fife have seen a world come and go. In between, a pride of old miners' houses marks the way, each with a neat garden in front and behind. Money may be scarce, but this is a fine place to grow and be. These are the council estates and striving unemployed that Channel Four left behind.

Across the road is a busy Workers' Education building, murmuring faintly that in past deeds and words is a future. There must be hope, or they would have gone elsewhere to find it. Hope is an anchor. Mining communities are dead, long live mining communities. With resilience, this place carries on. Come pit closures and the leaving young, 1921 and 2014, there will always be a Cowdenbeath.

Dundee

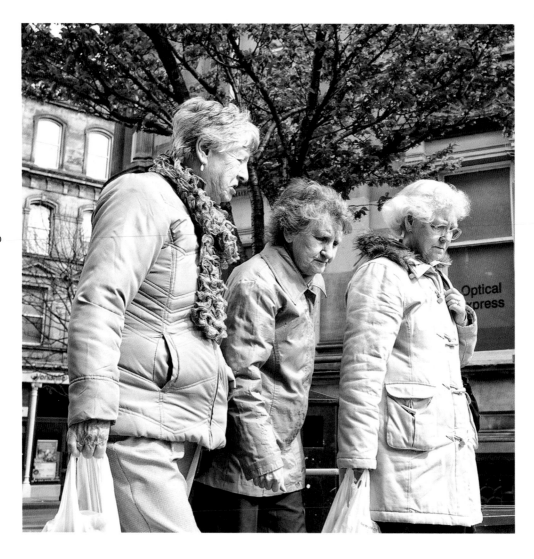

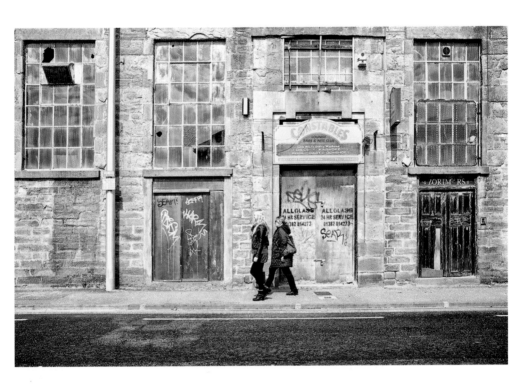

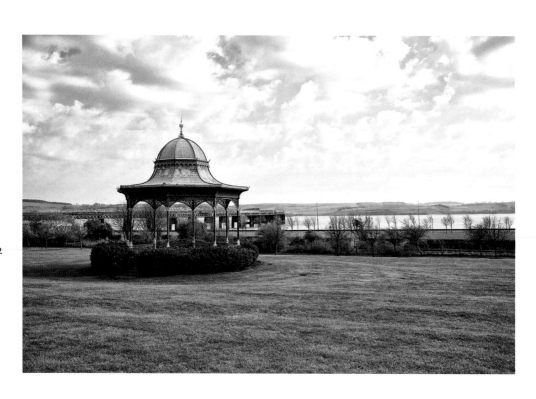

D undee loafs across a broad slope, clutched by the iron Tay. It is a long, wide city which beckons the visitor. From the train it opens its arms to you. It could even be offering a hug.

It would be looking over your shoulder though, looking out to a world it has so often embroidered. There are spires and tower blocks, and all the clanking rhythms of a metropolis. But put your hands in your pockets and whistle a tune, and genial countryside is a short stroll away.

The skyline has two civic punctuation marks. One is a War Memorial tower on the Law, Dundee's old volcano. It says to the visitor: 'This is us.' Far beneath is the other, a bandstand in a gentle park down by the river. Here, ladies raged and led the way: ignore Desperate Dan, for Dundee has always been a woman's city.

The bandstand sleeps on Magdalen Green, once a meadow of tumult. Here Dundonians gathered to vent against inequality, but also to offer answers. Women did not allow themselves to be left out. They were there to protest against the Peterloo Massacre in 1819, there in 1842 to roar for Chartism when shoemaker-preacher John Duncan called a city-stopping strike. No wonder Dundee gave us women of clout, women sadly lost to the public mind, queuing for museum space behind the great male discoverers of Tayside. Women like Frances Wright. She devoured socialist ideas and took Dundonian street angst to the United States. This energy was translated into Nashoba, a utopian community founded by Frances near to Memphis in 1825. She liberated slaves from their owners and invited them to live freely in her world: indeed, Frances of Dundee was the first woman in America to publicly denounce slavery.

A march away from the bandstand and alongside the Tay delivers us in brave new Dundee. The bulldozer has gone wild, erasing 1960s cement and 1980s social illness. Industrial shovels have cleansed the

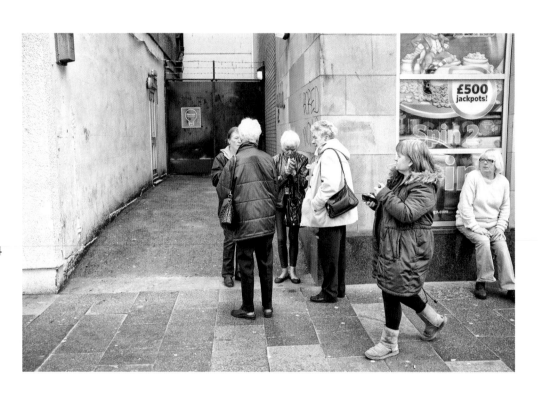

land flat and ready for the brassy and the new. The V&A Museum is coming. It adds to the inescapable feeling that something is happening. Dundee is rising. The new will have to impress the old. There's the Caird Hall for starters, a classy old girl, proper and pristine. In front of her stretches a square you could swear is continental, not that you would swear in front of the Caird Hall. Archways and pillars make for Madrid writ minor. A few streets away brass window railings cling to shabby tenements – Paris Ben the Tay.

It is a Bank Holiday Monday and people have things to do, benches to sit on and chats about rainclouds, neighbours and television to have. Women walk purposefully around with their arms like scales of justice weighing plastic bags; men perch idly wondering about their part in it all. The High Street clock and the clock hanging from H. Samuel have stopped. Perhaps Dundee moves to her own time. We join our fellow menfolk on the benches and realise that several moments are happening at once. The cobbles are sliced with tram tracks, while a busking band plays ragtime and skiffle.

Some people urban waltz to their trumpets, some don't notice they exist. A small crowd watches on, kicking at pigeons and sweeping Greggs pastry debris from their clothes.

Humour runs underneath the atmosphere. It is as if the happier side of being has jumped from the drawing rooms of DC Thomson and onto Nethergate and Commercial Street. Men with limps and walking sticks, fag-ash women outside the bingo and the small lad trying to persuade the tall lass to drink with him; teeny-boppers in pink bobble hats, embarrassing dancing granddads and a white Rasta man with nae teeth – these are surely cartoon characters, not people.

Reform Street is more like a boast than a thoroughfare, its bricks kissed with history. The buildings have a swagger. Off it is Bank Street, home to Kinnaird Hall, a century back another residence of female dissent.

The jute workers were Dundee's most radical women. Foul conditions bred defiant togetherness. Many worked in murky and choking heckling shops. They took their anger to meetings at Kinnaird Hall, and rowdily called out at anything

55

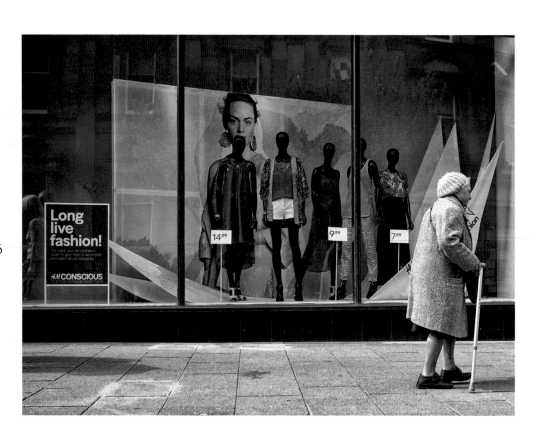

which stoked their ire. This gave the world another Dundonian invention: the term 'heckling'.

Their attitudes were perfect for the Suffragette movement, in Dundee a solidly working-class one. There was Miss Kelly, who scaled scaffolding and kipped in the Kinnaird Hall attic to disrupt an address by the local MP, Winston Churchill, and Miss Fenwick, the first female leader of a British trade union, prone to beginning meetings by asking a raised hand from any audience member who read the wrong kind of newspaper. And there was Miss Moorhead, havoc raiser, agitator, forgotten hero.

She pelted an egg at Churchill, smashed windows at the Wallace Monument, hurled pepper at policemen and tried to punch Prime Minister Asquith. With such ancestry, little wonder Dundonian men sit quietly on benches.

By the McManus Galleries we climb to the tranquil nether town, where jute women toiled and tormented. Mills queue for attention, smashed square windows that once flashed. Some of them have been reused, some left to age in their own time. It seems more fitting than renovation and yesterday looks resplendent in Dundee. The mills are more like cathedrals than factories, and ensure this city never forgets from where it came. It is just as well, because change hangs excitingly here. 'This was a dark place,' says a busker we stop and chat to in an underpass, 'But now it's back.'

57

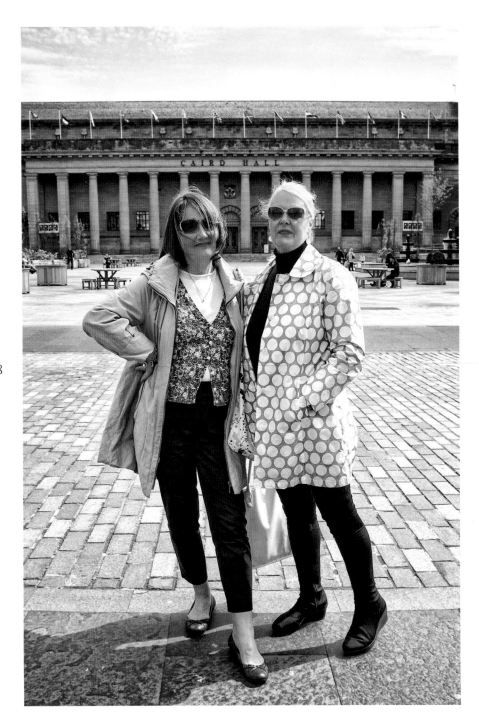

Pitlochry

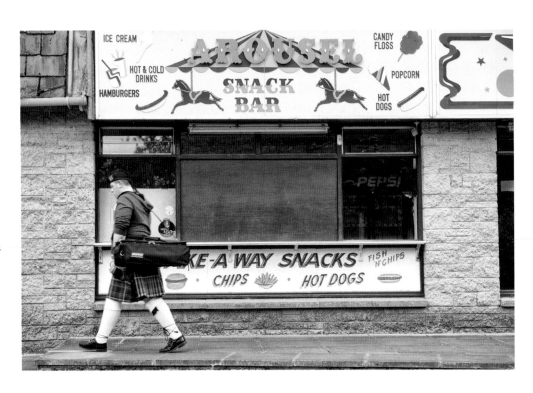

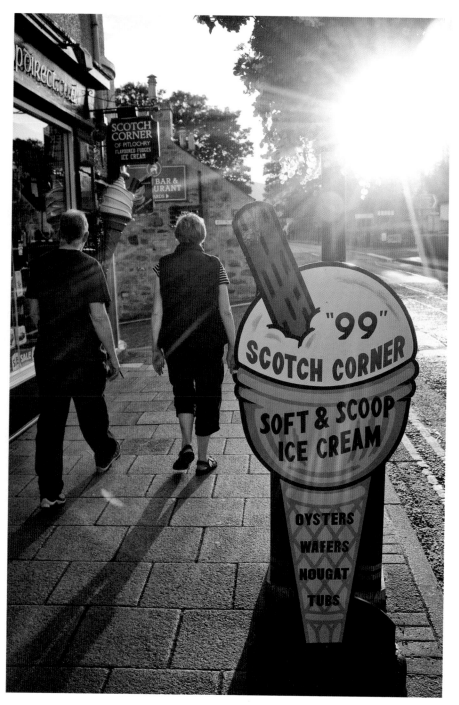

Thousands of hairy trees queue in tiers. Hill after hill they are there: sure, knowing, resolute. Every now and then, green gives way and the spaces are sprayed with bluebells. White and ginger cows stand around wondering why anyone would sit in a car.

The land is moderate, the hills subtle. Compared with the Highlands, Perthshire is a quiet uncle, content and wise. Tearooms outvote pubs. The River Tummel pulsates at the valley's foot, a lone dasher in a land of pause. It lashes at the wading legs of fishermen and makes sturdy pins almost crumble. A distillery invites the English and the Americans and the rest to pop in and part with cash, and brown signs denote that we are entering tablet and fudge Scotland for the first time on our journey.

The edges of Pitlochry are dotted with bed and breakfasts. Some look severe and probably still have curfews and proprietors with no first names. There are half a dozen campervans in the town car park, and a stocky man wearing smart trousers and a taut Superman t-shirt. Four cloudy-haired ladies load plastic bags full of woollen products into the boot. On the slope to the main drag, top halves are bent away from the direction of travel by heavy rucksacks, the knobbly knees beneath them left to joust with gravity.

Outside Scotch Corner, a tiny republic of nougat and fudge, a pensioner crew are in conversation. 'It's got a wee bit of spring, you see,' says one, demonstrating his new walking stick. 'I feel I can walk faster.' 'Go on, try the spring', he instructs rather than invites them. They all do, nodding away at the element of bounce. 'I just wanted something for my holiday, you know a wee treat.' 'He's easy pleased', says his wife and then she floats a smile of love and tolerance.

Pitlochry has cafés, souvenir shops and a Christmas emporium. It is not the easiest place to buy anything useful. The chemist's seems like an intrusion, real life creeping onto the film set. A man sweeps away at imaginary litter outside Pitlochry Knitwear and people sit in cafés thinking about

nothing. 'Sixteen flavours!' shouts a boy at an ice cream shop's window. By the cash machine, his parents fret about the cost of being away. Canopies line one stretch of shops, lending the feeling of a Riviera town and at the same time looking like moustaches on houses.

Most of the people here are on holiday. Holiday means passing the day, strolling, thinking about gifts no-one at home wants and finding a nice bench to do nothing on. Husbands walk ahead of window-shopping wives with their hands behind their backs. Sometimes they pause to glance at postcard adverts in the window of Sweeney Todd Demon Barber or smile vaguely at good luck cats knock-knocking at air in the Lucky Diamond Chinese chippy. They do not look happy, and they do not look sad, just occupied in making the clock tick faster towards lunch then tea then bed then tomorrow then going home. Laughter is absent and holidays are being done because they have to be.

In the park behind the war memorial a happy memory is made as two doting elders see their granddaughter walk for the first time. She is rewarded with proud eyes and

a foam tray of chips. It is now lunchtime and a dash of purpose has jolted the day. Two Spanish couples, the men in golf jumpers and caps, the women with mahogany skin that makes the sky even greyer, crouch to look at a menu. All around are people performing this manoeuvre, checking menus, walking on, and then usually coming back to the first place they looked at. They pass each other again and again in this pleasantly futile parade. 'Is Pitlochry only, like, one street?' an American teenager asks her parents. The parents fail to tell her that it has an iron road too, spreading to Inverness and watched over by a signalman in his house of levers.

The air is quiet here. We hear pitter-patter clip-clops clicking towards us from some distance. They are owned by a comely old girl – pearl earrings, bright lipstick and brighter eyes. She is a local. You can tell because she does not see tourists, gliding by with jobs to do, Bridge to play. Her focus adds to the calm of Pitlochry. It is sure of itself, as unchanged places usually are.

At the top of the town we see that change *did* come to this Victorian theme

park. Beyond the amusement arcade and the pitch 'n' putt, water is brought to life. The Pitlochry Dam was composed as Britain spent its way to glory after World War Two. Its art deco lines calm the eye while water whooshes beneath, the very soundtrack of progress. Inside its belly, turbines whir and we wish our Dads were present to explain how a river can turn on the lights. We queue to look into the Salmon Ladder, a gloriously anti-climactic side attraction. Inside, holidaymakers stare into a mossy screen, hoping to see salmon making their way upstream through this safe route. They cheer with alarming gusto when a pink fish does appear, as if the picture on their primitive television has, for a fleeting second, delivered. Then an angry man among them shouts at his camera for missing the salmon, and his wife ushers the gang away towards a tour coach that waits for no-one.

We sit in a fish and chip café that claims to have sold 'one million fish suppers' and look at our watches, another day in Scotland passed.

69

Caithness & Sutherland

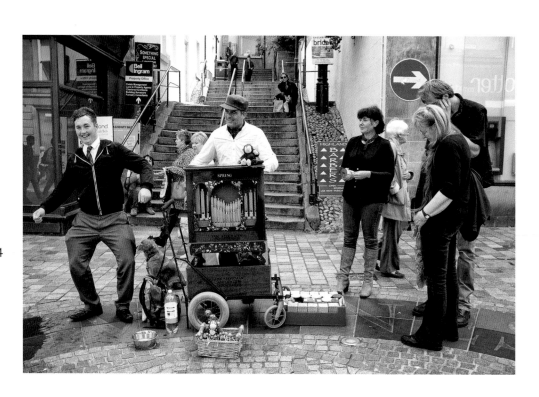

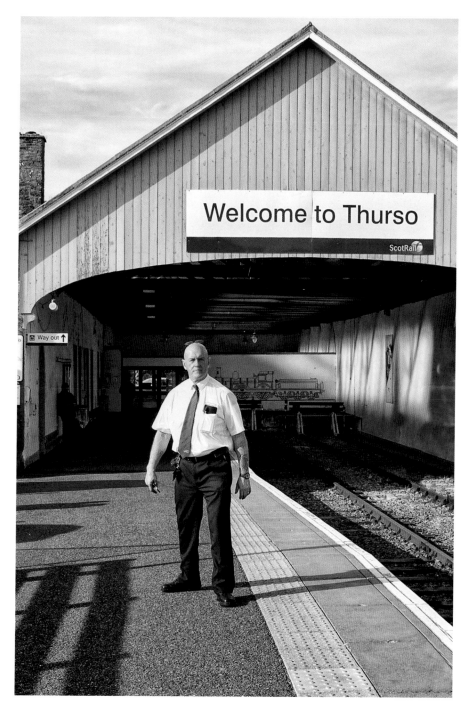

German tourists with rucksacks on their fronts and backs stride around in search of reason. They stop by the souvenir shops of Tartania and laugh at the pipeband pop soundtrack being spat into the air. Inverness is a passing time town.

Like the Americans in caps and the Japanese looking at maps, like the Scousers shopping for presents for Jane and Ronnie and Claire and Bobby, like the piss-bored teenagers and the mildly unamused old-agers – they are all passing time. It is not purposeless holidaying as in Pitlochry: it is to wait around for trains, buses and coaches, for Dad and Mum to load the car at Morrison's before heading to the magnetic north. Before you come to Inverness you think it is the north. It is just the pearly front gate.

They kick their heels in the Victorian Market, where the stalls sell the beautiful and the useless, and the old guard of fishmongers and watch repairmen all fancy the fairytale blond in the sweetshop. Her smile charms the baffled of Tokyo and the bored of Stoke-on-Trent. They go in to look at Sherbet Pips and leave thinking of Love Hearts.

More Berghaus vagrants are in the railway station. They draw deep breaths and read the destination list for the Far North Line we will share. Beauly, Muir of Ord (where a pretty girl in a hat who tells us about art school alights), Conan Bridge, Dingwall (where a ruddy-faced man opens the first of five beers he will drink), Alness, Invergordon, Fearn (where the station is someone's house), Tain (which has 16 letters in Gaelic), Ardgay, Culrain, Invershin (where a lady drinking vodka announces she has travelled from Stevenage to retrieve her son from his unhappy marriage), Lairg, Rogart, Golspie (where we stop on the way home for pictures, lunch and a lift, and think about staying forever).

Another breath, for the list goes on... Dunrobin Castle (where the ruddy-faced man burps loudly), Brora, Helmsdale (where the ruddy-faced man opens the

first of one bottle of wine he will drink), Kildonan, Kinbrace, Forsinard (where people come out of their cottages to look at the train), Altnabreac (where 50 stags run away from the train), Scotscalder, Georgemas Junction and Thurso (where we get off, with two stops to go).

Out of the window Sutherland and then Caithness smile at us, an epic arthouse film. For a while mountains tap the carriage on its shoulder and waves lick its face. Back inland, leaning scorched fences line the way and deer hop over them to find cover from our diesel multiple unit horse. Lambs are reaching the age where farmers start to see bhunas, and grouse arouse something in huntsmen. These ancient counties look like ambrosia but stink of spent rifles and warm meat on an aristocrat's breath. They are thrilling and base places. Perhaps things would be different had not the Dukes and Lairds cleared away civilisation. Perhaps they would be the same. Here, nature looks on at man's follies oblivious, everlasting.

Backpacks spill out into Thurso station with us. The sun is floating downwards, its early evening light delicious and calming. We all stand in front of a 'No Loitering' sign and loiter without intent, then split to walk wide streets planned in straight lines by straight men in the 19th century.

We are distributed to our beds for the night: hostels with fish and chip shops attached; bed and breakfasts with laminated rule sheets; hotels with brown net curtains, from behind which foreign diners slide their forks under ham hocks, tip them slightly and have a look underneath. Later in the evening, we will return to our hotel for a drink at the bar and one of us will ask the barlady 'How are you?' She will quickly look up at us and, instead of replying or saying hello, bark 'What time is it!?'

We walk along the river. On the other side was once a flagstone works reached by stepping stones. The stonedresser girls are no more; jobs come from the pounds of people passing through and a nuclear station soon to become a home for waste. The picture is not as grim as that, though. At the seafront, everything pleases the senses, though they are shocked when first they see the Orkney Islands so close. It

79

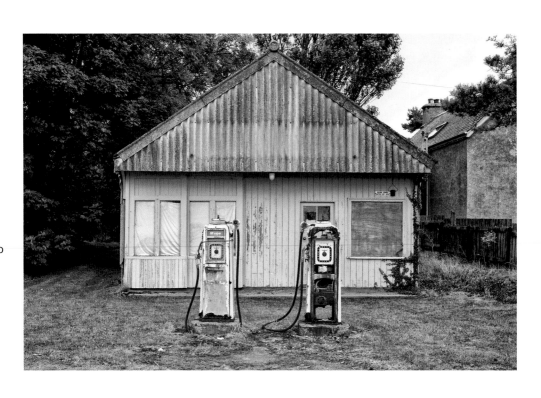

doesn't feel like there should be anything after Thurso except the end of the earth.

It is that other world which makes Thurso another passing time town. The backpack hoards and the net-curtain diners are here to gather sleep before sailing. This is a shame: Thurso deserves more commitment than a one night stand. The time-passers fail to see the noble town hall, or wonder why a place this small needs a Mason's Lodge the size of a minor French castle. They do not stop in the park, look at the three statues in a row and shiver with the thought that they are part of something bigger.

Tents are pitched on the cliff above the beach. Four men raise a Czech flag and open frothy cans of lager that whistle.

A couple huddle in front of a disposable barbecue, a few quid spent in the Lidl across the road added to this view mean incandescent happiness. Less happy is an American in the pub we eat in. 'Is "beef olive" a British thing?' he asks the waitress, a sweet goth with dreams of Inverness, the big city. He talks loudly of sales techniques, while a group of young Yorkshire folk debate loft insulation products.

On the way home we peer into a golden window and see an accordionist playing 'Waltzing Matilda' to seven pensioners in a tatty hotel lounge, and we see some graffiti on the wall of a former water waste treatment works: 'THERE IS ALWAYS HOPE!'

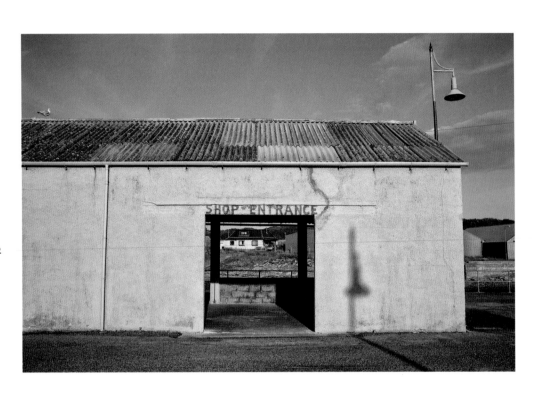

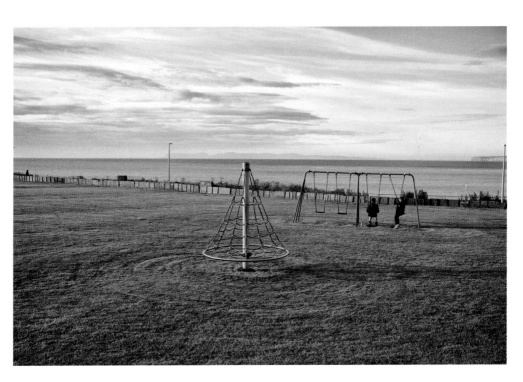

Hebrides

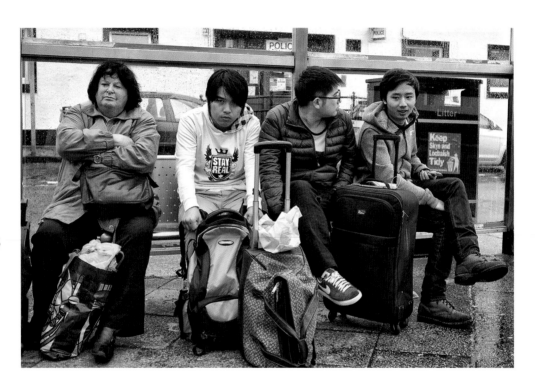

They stop to chat beneath umbrellas. Two old ladies of Skye, discussing supermarket offers. Visitors buzz all about them, frightened of the rain or of missing a photograph. The Portree women are street furniture, everything else is chaos.

What is it like to live in these surroundings? What is it like to buy your bread or open your test results beneath improbable mountains in a brochure landscape? The oblivious old ladies have it right: let Skye surroundings go to your head and you might think yourself the member of a chosen, blessed race. That will not do in the hard world of the Hebrides.

The road spins us towards the ferry terminal at Uig, our eyes numbed and glazed by beauty. Ferrymen in fluorescent jackets knock on windows and wake entranced passengers. They have forms that need filling, paperwork in triplicate. MV *Hebrides*, built in another Scotland we will soon see, slides across the water and opens her arms to Uist brothers going home, lorry drivers charged with bevvying up the islands and bemused tourists under the commandments of *Lonely Planet* guides. There are skilled workmen on jobs seen as jollies back at the plant, and a minibus of soldiers, bound for Benbecula and South Uist, where things that kill have long been tested.

This ragtag community bounces across the waves. All nostrils are filled by canteen scents, all eyes soothed by the ripples then ribbons of bumpy green land that appear in the ship's fish tank windows. Signs on doors and walls have a larger font for Gaelic than English, a quick word in our shell-likes that here, other words come first. We cut through a fog and North Uist can be seen. The ferry society disbands and spills from the boat, except for a young Spanish couple on a cycling holiday. They pause on the landing ramp, rain coating their faces, and think about what they've done.

Big cars pull up and whisk mums off to other parts of these islands. We remain in Lochmaddy. I think of Edwin Muir

89

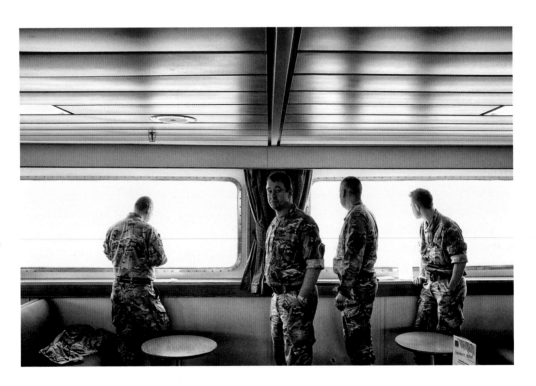

talking about the Highlands in *Scottish Journey*: 'Everything had the look of a Sunday which had lasted for many years.'

There is a hotel with restaurant, lounge and public bar. The public bar has no windows and a sign above the door which reads 'Temple of Happiness'. Inside, the walls are caked with all things Glasgow Rangers FC. Scarves, stats and crude assumptions will tell you that North Uist is Protestant, Benbecula a half-and-half buffer, and South Uist is Catholic. Lochmaddy has, too, an arts centre and Post Office (both closed for the day), and a shoal of bed and breakfasts in modern pebbledash houses built not to please the eye but to rebuff the elements.

We drive the road which nooses North Uist. Burial chambers, cairns and war memorials are plentiful, people absent. Houses and services are built miles apart, adding to the sense of perfect wilderness. There is a village hall with no village. Only post boxes remind us we are on earth. Behind one is a thumb-shaped tower in the middle of a clear loch. It was built as a famine relief project in the 19th century.

These lands may seem otherworldly, but they are scratched by the same claws as everywhere else. Child poverty is high, life hard when your job centre is 100 miles away, and jobs themselves even further.

Remoteness twists the knife, driving up food and fuel prices. At night in the Lochmaddy Hotel, an old-timer from across the Sound of Harris tells us how Outer Hebrideans forgot to use their hands.

> Before the supermarkets came, we could dig and fish. Then it became a status thing to shop. Now we can't afford to shop and we can't remember how to dig and fish.

All is not lost: we meet crofters and fishermen too, mostly young and fiery. Besides, the Spanish cyclists and the French families in mobile homes bring pounds in exchange for white beaches and glassy waters that are going nowhere.

A causeway takes us over to Benbecula, a small island between Uists. Burning peat fills the air. It smells like a damp bonfire night. There are mountains and then vast flat spaces curbed only by the sea. The peat air also whispers legend and mystery. In the 1820s, it says, seaweed-cutters here saw

91

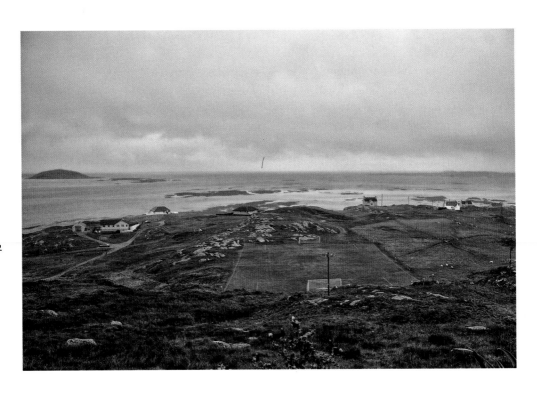

a creature they described as 'a woman in miniature'. She had a small upper body and dark glossy hair, but the bottom half of a giant salmon. When her body later washed up, it was thought human enough for a religious burial, and mermaid enough to be magical.

Halfway down Benbecula, spartan 'Wee Free' churches of the North give way to Catholic shrines in beige and duck egg colours. One – Our Lady of the Isles – is a sizeable stone sculpture on the side of a mountain. Beside it are two giant 'golf balls', used by the Ministry of Defence to track missiles. It is the most incongruous sight of our journey, and only the raindrops that rap our faces like blacksmiths' knuckles remind us that we are in 21st century Scotland.

Onwards we push, through the glorious and bleak spaces of South Uist, and find the postcard beaches and seas of Eriskay. This is Scotland and so there are ghosts, ghosts and more incongruity; in this beauty were horrors made. For years had the lairds and landowners of these islands seen their residents as ants for stamping. The Clearances were just the thing. Vile General Gordon of South Uist forcibly shipped 2,000 people from these beaches to Quebec. Refuseniks were hunted by dogs, caught and thrown onto ships to sail in pens. 'I am neither legally nor morally bound to support a population reduced to poverty by the will of Providence,' he said. In the North, Lord MacDonald evicted a thousand families from their crofts and had them shipped across the water too.

We stand on a perfect beach, we stand and we realise that the next place after here is Canada.

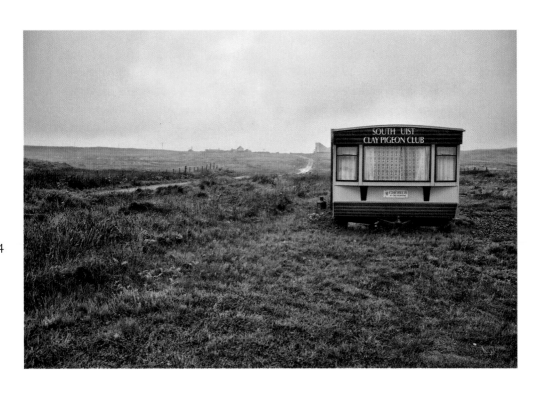

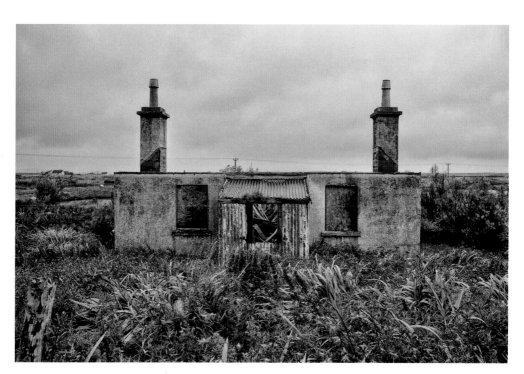

Inverclyde

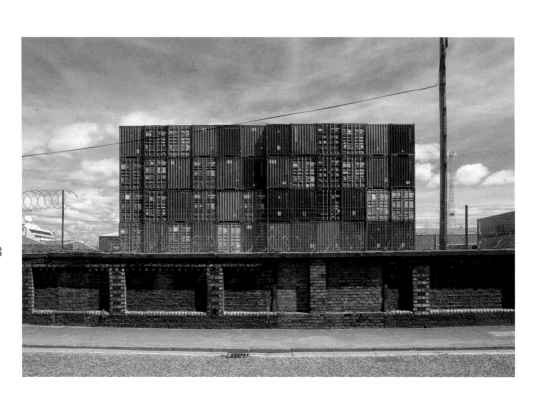

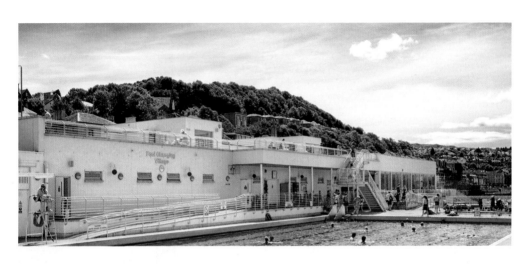

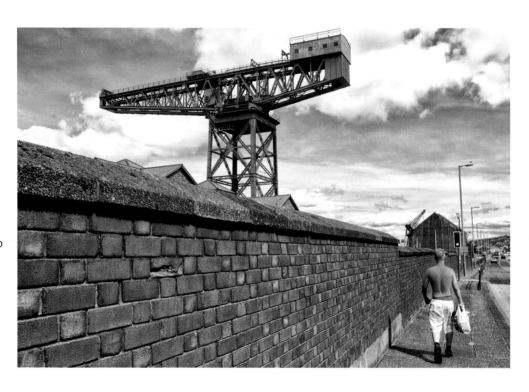

Our train stumbles out of Glasgow making click-clack noises from another time. On a luminous morning like this one, Scotland has a foreign accent. It slips only when crimson tenements slide into view.

At Paisley an old man in a funeral suit shuffles on and mops his brow like a character in a Kronenbourg 1664 advert, fitting the continental drift. He has ruddy cheeks and the story-filled eyes of a rural Irish poet. Again we are fetched back to Caledonia by the pretty woman opposite. In deepest west coast pitches she speaks into her iPhone about last night and other things that matter. 'Does he call himself "Nicholas", seriously? It pure reminds me of Santa.' 'Did he have a French accent? A real one? Jesus.'

The tide is out, laying much of the Clyde firth nude. It looks as though an almighty hand has scooped it barren. Land is marked by places that used to clank and purr. Lanky cranes at Port Glasgow quietly sleep and are quickly followed by consumer wastelands of B&Qs and Tescos. 'Inverclyde' is a relatively new concept, its 1970s Latin motto *Meliora Semper Prospicimus* – we look forward to better things.

We arrive in Greenock and find ourselves sniffing the sickly scent of hash in the morning. It seems unnecessary as the older buildings of the town are a wonderful hallucination in themselves. Gargoyles ride the side of mercantile buildings and dainty frills make corners ornamental, not functionary. Some of the bricks have uneasy foundations in the slave trade: to walk Greenock streets named Virginia, Antigua and Tobago is to remember that this is an Empire town, the Liverpool of Scotland. An information board tells us that English was seldom heard here in some 19th century years, such was the human traffic passing through and bustling about.

Trade with the Americas grew a port town from a fishing village. It meant sugar refineries, wool factories and shipyards, as well as those people on the move. Some were sailing for new lives, some were bound by chains. In that 19th century, Scottish tycoons owned a third of Jamaican

plantations. Time healed the wrongs but also tick-tocked most Greenock industry stone dead.

From every angle the tower of the Municipal Buildings can be seen. When they opened in 1886, the *Greenock Telegraph* opined that they had 'every beauty but the beauty of economy'. While thousands of locals dwelled in slums and fought for dregs of dock work, Victorian hats splurged the family silver on a work of wonder more suited to Florence. It has a chunk missing, where today in front of terracotta walls people sit on benches eating, smoking and in one lady's case reading an article whose headline is MAN I FELL FOR POISONED MY CAT. Watching them is like looking at a stage set, or being in a half-room. This is Cowan's Corner, named after heel-digging shopkeeper Robert Cowan. He resisted climbing bids from the authorities for his land so that in the end they built the Municipal Buildings around his shop, a crow beside a whale. Then in May 1941 war did what the Victorians could not, obliterating Cowan's shop. Over two nights, the Greenock Blitz killed 280 people, injured 1,200 and left half the town's housing inhabitable. The second night was the worst. Then incendiary bombs fell onto a distillery inflaming the night sky, a deadly signal flare for the Luftwaffe.

They seasoned Greenock with high explosives and parachute mines. One bomb killed a family of ten, making a crater of their underground air raid shelter. The coming of daylight was akin to pulling back the curtains and finding hell: at that family's address, rescuers found only clothing, a purse and a charred bank book. Those that survived the Greenock Blitz flicked Vs into the sky by crafting posh clothing of silk parachutes found among the debris.

A secondary war crime, this one self-inflicted, saw a concretopia rise from the ruins. A motorway splices old Greenock from the waterfront, de-socialising the town, so we walk through sad underpasses. The tips of cruise ships can be seen, and pale bronze types in polo necks amble about on their brief shore leave. They look surprised when they see the beauty sprayed around this town they hadn't heard of ten

103

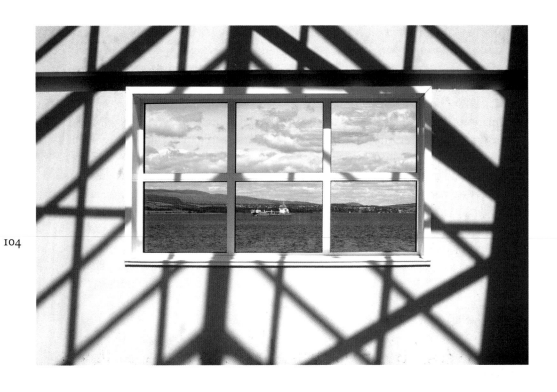

minutes ago. People are rendered insignificant by the container stacks of Clydeport, which hums and tolls like the Greenock of old.

We smell the sea and hear the seagulls. At the Esplanade eyes are closed and heads pivoted up to a rare furnace sun. Lunchbreak office suits are the wrong kind of clothes for this weather: dense patches can be seen on shirts, sweating backs like oil lapping at a blanket. Behind us are seaside homes and rigidly artful tenements, in front the wide water and then the peaks of a different Scotland.

We walk onwards, to Gourock. The houses grow larger and more stand-offish, the old homes of the merchant kings. Then appears the picturesque Mariners' Home, its Royal Navy standard fluttering, its sign offering old sailor residents 'The gateway to a safe anchorage'. As in so many wealthy suburbs, there are few people around to colour the afternoon. After Fort Matilda begins Gourock, where Zippo's Circus has arrived and where the joyful cluckings of children playing float in the air. There is a harbour with hobby boats and a trendy fish wagon called the Platter Merchant. In less than two miles, we have strolled the class system.

On the main street modern Robert Cowans perch outside their shops like old Greek ladies at the tavern and apron-smart waiters serve half lagers in The Continental café bar. We reach the lido, a Cezanne painting of blues, whites and bobbing flesh. *The sweetest of songs is the song of the Clyde*, say the words chiselled beneath a statue.

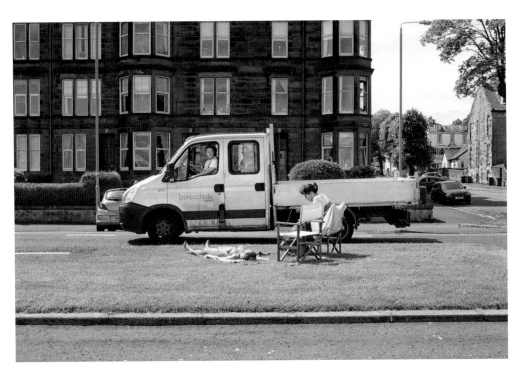

Govan

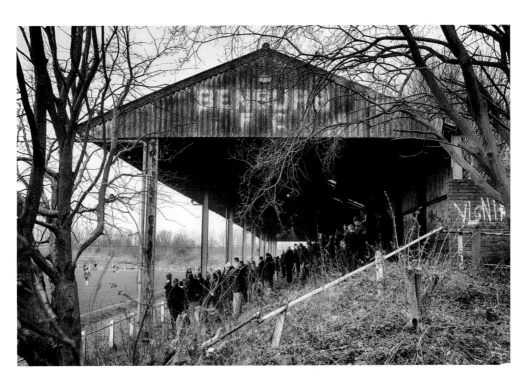

The glowworm slithers around its loop. Every few minutes it jolts still and fragments of passenger conversation can be heard. Natter progresses and digresses, grave voices turn to laughter between Kinning Park and Cessnock.

We ascend from Ibrox, a bright refurbished station of the type that usually happens in France or Beijing. A bright young thing shoves the barrier, greets the girl and kisses her convincingly, as if he is just back from war. Opposite is the Louden Tavern, a hyper-bar. Its bold letters declare it 'The Quintessential Rangers Supporters Pub'. Our ball-shaped hearts are across Govan, though, at tired, gorgeous and soon-to-be-bulldozed Tinto Park, home of Benburb FC.

Around the corner, we find Govan Town Hall. It is a scarlet mansion sprinkled in carvings and domes, a solid marvel. There is nothing around it: no tenements teeming with life, no shipyard shifts coming to an end and no pubs to slake a riveter's thirst. A few decades back, men in suits across the Clyde decided to delete half a town. 'Let Glasgow Flourish', says the vintage city slogan. Perhaps the subtitle was: 'but knock it down first.'

Moss grows across old dock cobbles like facial hair. Grass and weeds take the land back, daisies and buttercups rise where heavy boots clod-hopped and dandelion clocks mark time. The water ripples politely but it is quiet, a limp cadaver. Birds set the tune, swishing trees the rhythm. The song says: 'Things happened here.'

An old boy on a bike rolls up to the barrier separating land from water and looks forward into the past. He sees vessels being born and hears noises to make him deaf. The present interrupts – you can see the light fade from his eyes – and he sees glass: the Science Centre, the SECC, the BBC. New jobs, new Govan. Nothing made but daytrips, nights out and telly.

Perhaps he wonders how many of those who flick switches and man Apple Macs are 'of' the Govan they work in: how many live here, how many will fall in love here and make Govan families like he did? How many will commit more to the old town than a lunchtime panini?

113

We walk by barbed wire then find a hole in the fence and another yesterday. Govan Graving Docks are a decadent museum with most exhibits removed. Wire ropes as thick as bear fists snake underfoot and the pumphouse looks on like a mothballed Tuscan villa. We could stay in this decrepit heaven all day, but turn to leave. A figure in black is climbing through our hole in the fence. A security guard? A ghost? As we pass, his weathered, cobbler's-apron face is unmoved. He does not turn his lost blue eyes towards us. I think of the industry that has gone from here, of the workless battalions left behind, and of Edwin Muir quoting Rosa Luxemburg on the unemployed masses in her day: 'The dead on leave.'

This half of the mighty Govan Road suffered most from the whim of the wrecking ball. Sporadic tenements the colour of dusty cherries salute what was, and between the gaps useful things are happening again. Some of them, like colourful housing more Stockholm than Scotland, are even beautiful. There is a multi-faith school where kids screech away playtime and adult-contrived difference.

It is the first sign that Govan remains alive. The second and the third and then the rest come quickly.

Govan happens first outside the shopping centre. There, old pals chat in scattergun tongue and laughter sucks any sadness from the air. They are oblivious to the noise of building rising around them, an indifference biological among the shipyard race. A toddler drops a toy in a puddle. Mum asks his big sister to fish it out, which she does: 'That's pure boggin', Mum, I cannae believe you sometimes.'

Opposite, the parish church waits handsomely for some peace and an old lady finds it with a ciggy by the cherub fountain. The Pearce Institute is ornate, worth the glowworm fare alone, and a Govanite tells us about its pub neighbour, Brechin's Bar. 'Naebody calls it that. It's the Black Man to us. You can get anything in there: TVs, clothes, STDs.'

After this, Govan Road becomes a proper, scurrying high street. Hungry, filthy shipworkers file by the Fairfield Gates in British Aerospace jackets and jeans and towards dinnertime. They are gradually swallowed whole by a mob of

115

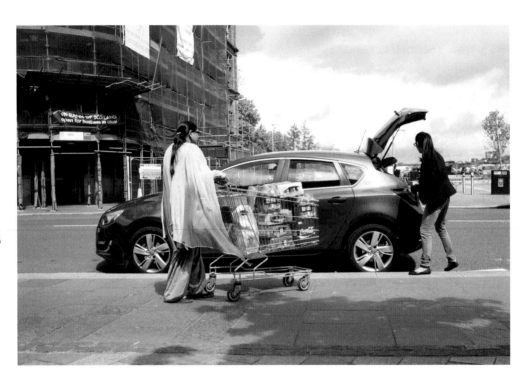

flirting teens monkey-parading around the old Lyceum Theatre, a pretty, neglected face requiring make-up. In the doorway of Sunny Govan Radio a man reads the *Govan Press*, oblivious to a nearby quarrel about late library books between father and son. 'I'll not be able to show my face in that library,' says Dad. In all this can we interlopers see Govan for what it has long been: a town within a city. Before it was that, it was a town of its own, Leith's Clydeside brother.

This town has resisted some outsider 'gentrifying' it: the pubs are drinking pubs that serve pies or toasties and Nolan's Fruit Bazaar knows where you can stick your Tesco Metro. The pillage of Govan and the swagger it nonetheless maintains reminds us that working-class places should not be managed into beige oblivion, the character regenerated out of them. Luckily, though, history changes appearance but not atmosphere, which is passed on and inherited. Just look at those snarling, merry lads. Govan is in the air, not just on the ground.

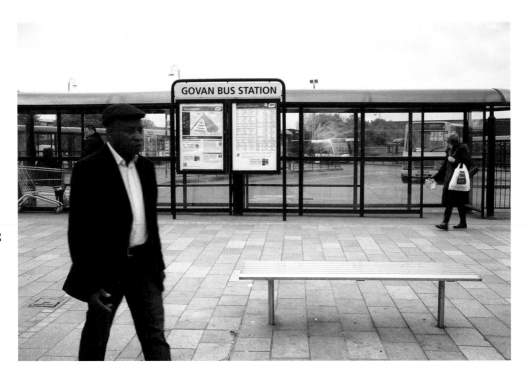

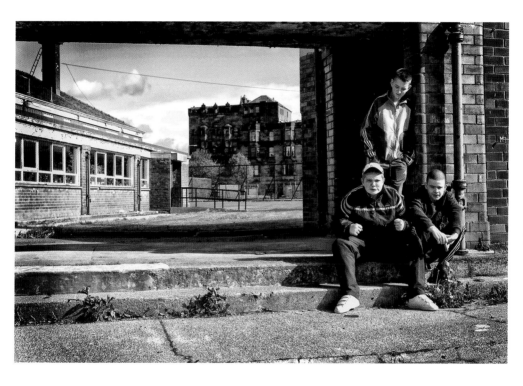

Doon the Watter

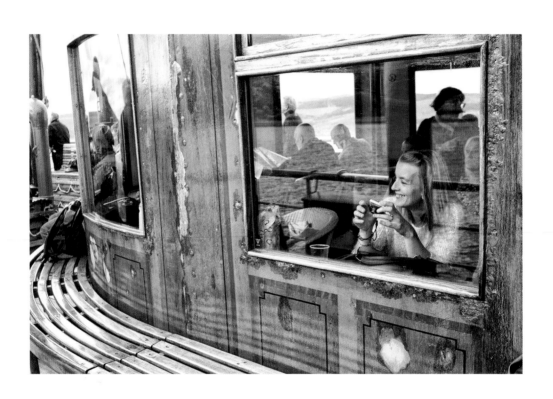

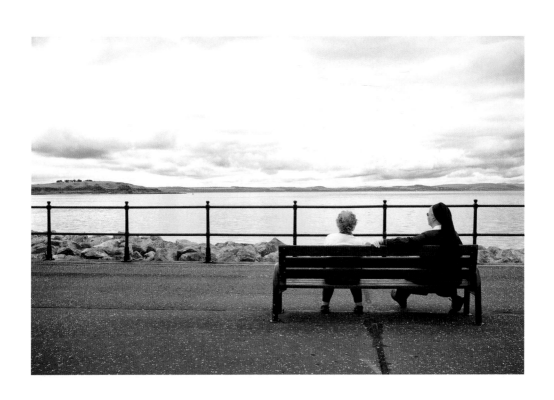

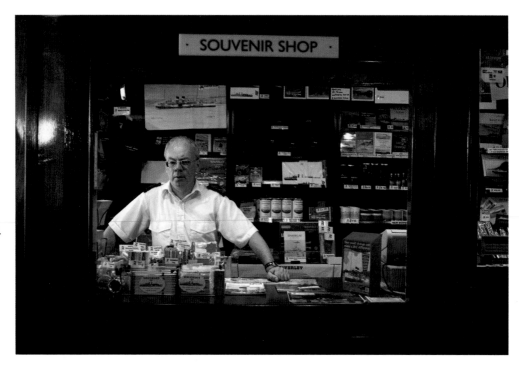

The River Clyde, Fair Fortnight three days old. Fair Fortnight, when old Glasgow hung its bunnet on a shoogly peg and stuffed its hairnet in a drawer. Two weeks were theirs, theirs away from bosses and the tyranny of steaming chimneys.

With the slam of a tenement door did the chains peel off for a fortnight. Most headed for water – the ferry home to Ireland, the charabanc and train to a loch or, best of all, a paddle steamer 'doon the watter'. Such frothing beasts pounded their way over the Clyde and deposited fair fortnighters at Helensburgh, Rothesay and Largs. Their boarding houses awaited. Some still take off these first weeks of July, tied to the tradition, if not the shipyard or the factory.

It is Fair Sunday, and all of us – old men and women who remember those bunnet and hairnet days, their children wondering when it is acceptable to open canned beer and handbagged voddie, their grandchildren playing games on tiny screens – are going Doon the Watter for a day, an expectant army marching on bacon rolls. 'This vessel replaces the Clyde steamer *Waverley* which was built in 1899, served as a minesweeper in the 1914–18 war and was sunk by enemy action at Dunkirk in 1940,' reads a plaque in bold brass, this country as ever stalked by history.

Wooden walkways, benches and walls are sharply varnished, the funnels dusk red and a crew busy about dressed all in white like functional angels. It is a black and white experience in full HD. The boat hammers up a surprising tempo, chugging and clanking us out of Govan and through Clydebank, spaces and cranes. 'Roast dinners will be available on a self-service basis, that's roast dinners on a self-service basis' crackles the tannoy. The Clyde fattens and the countryside runs wild, mountain peaks and untroubled islands.

Some passengers snooze propped against funnels, others pursue the age old battle between broadsheet Sunday newspaper supplements and the wind. Couples rub noses, gangs huddle in the bar. Another set of people look out to the

125

water and shake their heads with half a smile, remembering. It seems like a celtic 'Thin Place', not one where heaven feels closer, though: one where we can feel the breath of the past against our necks.

'Apparently there's a special word for the feeling you get when you've left your mobile phone at home,' says a bloke in his 60s, peering up from his *Sunday Times*. Gradually the Clyde becomes more like the ocean and the air moistens. Two women in sunglasses pinch their hoods tight to their faces. 'Will we go inside, Susan doll?' 'Aye. It smells a bit "seaside" now anyhow.'

The wind rises and more people follow them, most to one of three bars. It seems half the fun of going Doon the Watter is missing going Doon the Watter. There is an attractive ambivalence to hiding in the dark hull of a ship while Scotland puts on a show. It suggests a knowledge that she will always be there for people when they need her, but photos and maps are for tourists. To go Doon the Watter is not an act of vacation, but an act of ritual.

For most of the journey, a commentator tells people what they would be seeing were they looking outside the boat. He stands behind a funnel, a plastic bag filled with scraps of paper and local history pamphlets for that moment when a year or name slips by him. Sadly, his words can be heard only in between the sea gale. It is like drifting in and out of consciousness during a school geography lesson. There is more schooling in the engine rooms, where dads and their sons and daughters point at whooshing pistons and draw pictures on pads bought from the souvenir counter.

On the shore, blinking lights, the faint rhythms of fairground music and the elegant art deco edges of Nardini's ice cream parlour mean we have reached Largs.

The boat hums its way into the harbour and the gangways are lowered. 'I feel FREE,' says a girl in her late teens as our shore leave begins. 'Aye, they were the worst people ever, like,' replies her boyfriend. The seaside streets lack people: most are in Nardini's.

Among reassuring décor, booths and wooden partitions, waiting staff hover around balancing trays of vivid treats and fish 'n' chips. There is a pianist in the corner, but his velvet tinkling is out-

muscled by chitter chatter and laughter. Every drink still legal can be had here, but no-one is on the booze. It's a teapot or milkshake kind of place, a glass bottle of Coke or hot chocolate one. The two tables nearest us sum up the wonderful universality of this place: on one, two pensioner blokes contentedly ignore each other while reading the Sunday papers; next to them, a lad and lass of no more than 15-years-old sip from strawberry milkshakes, nervously falling a little bit in love with each other.

On the Esplanade, between palm trees and a giant sculpture of a Viking warrior, families eat picnics. The beach has a smattering of folk hobbling over its cobbles. There is more colour yet in Beachcomber's ice cream, hot dog and candy floss stall, everything soundtracked by arcades. Inside these multi-noised meccas, grannies bet 10 pence, and a gang of young women dance around screeching like worries are things that happen somewhere else. Slot machines called 'Disco Fever' and 'Salsa' flicker away, and children put all the pressure of their young hearts on their Dads to pluck a win from the grabber machines.

By 'the shows' – Kiddie Kastle, Krazy Kars and a set of trampolines whose sign asks participating bouncing toddlers to 'Remove all sharp objects and coins' – we sit by an old man on a bench. 'It never stops, does it,' he says fondly, shaking his head. 'It never changes.'

Galashiels

In luminous jackets they build the future. Beside the spinning road to Galashiels they are there, the busy navvies of a more careful age. The railway is coming. Towns need trains and 'Gala' is getting hers back.

Seeing toil on this scale is no longer part of our collective memory. It is a happy shock. We have forgotten that we can still make things happen and shape the way, still develop our land and lives. Another urgent corner is turned and Gala languishes in front of us. Here is a town sunk into a valley, as if tenderly landed there on ropes by the clouds. Houses based on 100 architectures in silvers, browns and maroons claw onto the hillsides all looking down on chimneys, turrets and spires. Mills, some disused but many reused, pock the skyline with identity. Gala's main street has its back turned to the river: this was a weir to live by and not on, water was work not a place for pleasure.

Perhaps pleasure comes up the road at the rugby or the football next door. The round ball pursuit is a less popular one in these southern parts. Gala Fairydean Rovers must try extra hard. Perhaps that is why, for their main stand, they have a Brutalist experiment. Its edges and triangles speak highly of yesterday's future and stand out as an act of surrealism against rain and the fresh valley.

It is Friday lunchtime. In the model Victorian primary school, a bell tinkles and children burst out of doors and throw themselves onto climbing frames and into games from cuter times. There is no happier, more timeless din. Downhill, teenagers pour from their school gates and lumber into town. They form heavy queues outside dinnertime takeaways, seeking fried things to feed the teenage mind. Ordering a sausage supper or battered pizza could be this summer's Braw Lad. Every year, one is named and gets to ride a horse through town surrounded by a pipe band. Rabbie Burns started it all.

There is a Braw Lass now too. Perhaps she sits among the sandwich girls looking

137

out to places where stuff used to happen. Perhaps they know what a frantic town this used to be, perhaps their Granddads told them. Now, behind a traffic jam of handbags, they just look on at a Tesco and an Asda. Those two ultrastores pick off high street shops like assassins. In the whitewashed window of James Brydon Hogg, butcher, a goodbye note reads: 'I would like to thank all my customers, past and present, for supporting me over the last 30 years.'

An old man as tall and thin as an LS Lowry character, half-mast trousers and a Steptoe-jaw, spindles through the door to Macari's Café. We follow him into the golden light. A baker's dozen of women make the noise of a century and local radio buzzes along. Clanking trays are slid along metal bars, order tickets taken and sauce sachets plundered. In Scotland, we know this much: you can never go hungry or grow unhappy with chips.

Gala is sprinkled golden with institutions and clout. The Burgh Hall, its Braw Lad on a horse and its war memorial stand steadfast. Burns and Scott look across a road at one another, a steep and encouraging library between. A man in his 20s leaves that library huddling a bale of hardbacks, his something for the weekend.

Up beyond Tea Street are long rhythmic streets of mill houses and chunky gable ends. 'Ah mind the rows and rows of buses for the workers dropping them off here,' a lady in a plastic polka dot hood tells us. 'They came from miles around. Even Dalkeith!' She continues: 'Then there was the electronics. The Americans came in. "A future so bright you'll need sunglasses" they said. Then they closed it all down.' Now, the skilled young leave and the unskilled are left to find jobs that don't exist. There is hope in the railway. On a particularly rainy day, it may even be last chance hope.

On Bank Street a human lifespan gently flickers by. There is a sweet shop at one end and a funeral parlour at the other. In between are all other stages of being. The street sustains Braw Lads and Lasses with a butcher, baker and fishmonger. In Reiver Properties – these, after all, were Borderlands of pillage – homes can be bought and made. There is a jeweller for when wedding bells ring, clothes shops

139

for her and fishing ones for him. Hair is cut, eyes can be tested and prescriptions can be picked up in a hardy paper bag that crinkles. Hearing aids can be bought when things grind slower and mobility scooters when the world starts to turn too fast.

Opposite, the pretty park with its regimented flower beds has a surplus of benches, each holding up a dedication plaque as if saluting. Two late teen girls perch on a wall, their legs swinging. Only pigtails and lollipops are missing. 'John's OCDs are amazing,' says one, 'proper amazing. You should see his sock drawer. It's like a museum or something.' 'I want some new OCDs,' replies her pal. 'Mine are boring now. Craig from the pub, he's got some cool ones. I might ask him.' A gent that must seem to them 101 years old stops by the wall, his cocker spaniel protesting by heaving the lead. He has a bald head and chest hair intruding over the neck of his sweater. It is like ivy clawing at the moon. The girls probably laugh about it. 'Hello Sarah. How's your John getting on?' he enquires.

Whole lives are lived well in Gala, lives that never really bother anyone else in any other town, but lives that matter here. The drama of the setting makes for a content place, a model railway town that is about to get its trainset back.

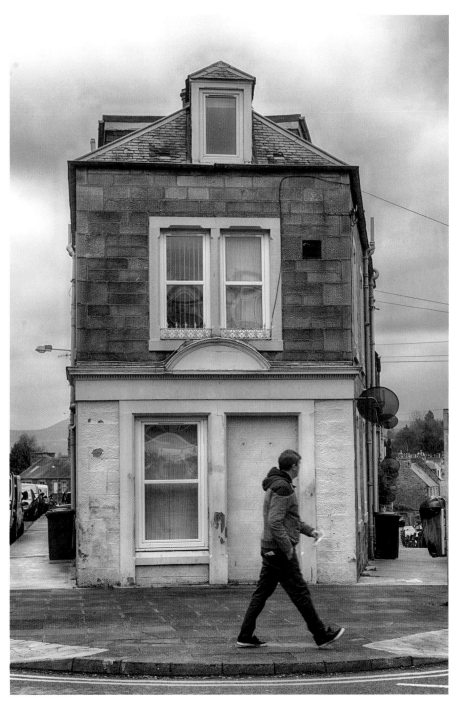

Borderlands

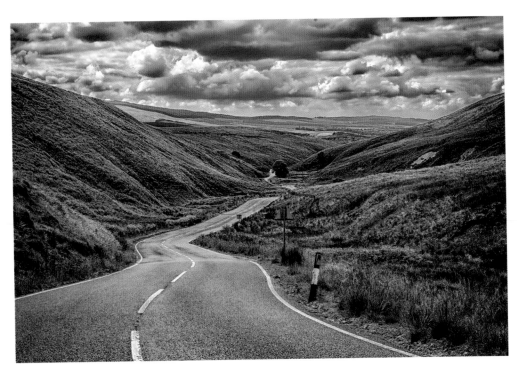

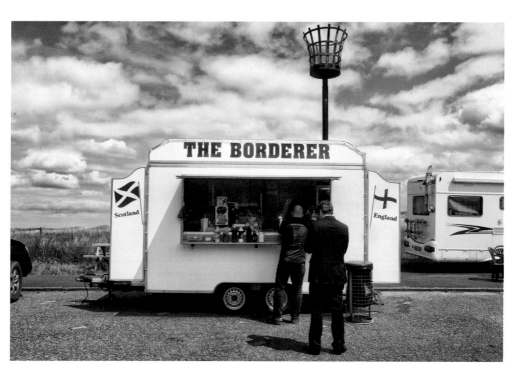

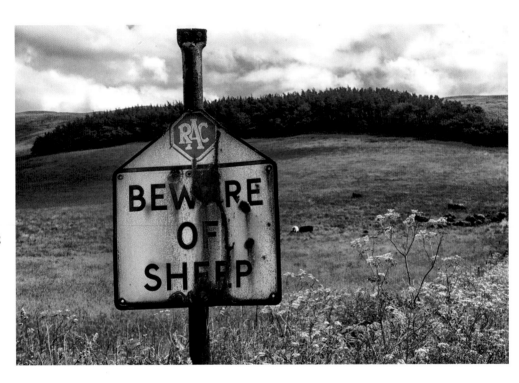

One of us is Scottish, the other less so. As we have travelled for this book, the border between our countries has mattered. Scotland in the time of the independence referendum was a fascinating place.

Yet it was not *that* much more fascinating than in years past and probably ones to come. That is not to dismiss patriotism, nationhood or schemes for a better tomorrow, nor to side with Yes, No or the great unheard. It is just to say that Scotland is not written in White Papers or Think-Tanked into a 'vision': it is lived and living. It lives as many versions, as we hope we have shown. The shortbread tin has never spoken the truth. Flags and borders matter to some people, that is their Scotland, but a country is what *you* make of it and what *you* want it to be. It is not uniform.

If borders mattered, we thought, they would matter most in the Borderlands of south-east Scotland. These were the territories so viciously fought over, on each side penny-chasing warriors chucked into battle by land grabbers with crowns. It was in the blood.

Away from the main roads in the countryside, blood, battles and borders are far from the eye and the mind. A sign hints at commotion by offering BULLS FOR SALE, but this is more a land of egg baskets inviting you to take what you need and leave a quid or two. Sheep cling to hills and tut at you for breaching their peace.

We see an old couple in farming clothing from another time, stood by the road waiting for something or other, and wonder about their lives. The same thoughts surface when farm houses and their crowd of accompanying buildings ease into view: are these lonely or happy lives, or lonely, happy ones?

To stop and wander is to listen. There is a special kind of quiet here which seems to make a noise of its own. It is a perfectly clean one that hangs all about you without being oppressive, making for the freshest of air. Every now and again there is a bird happily chatting away to itself. These are the Still Lands.

Back on wending roads with dainty

149

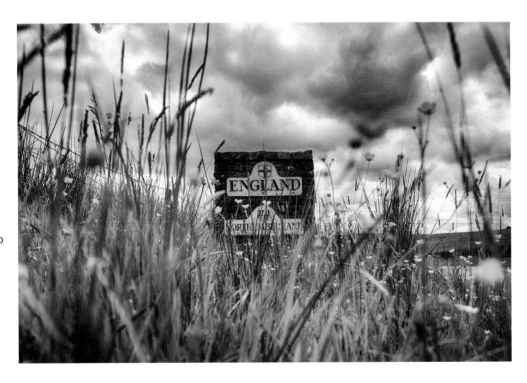

hump bridges we occasionally pass pubs called The Horse and Hound or The Plough Inn. There are foals and follies, built by yesterday's aristocrats, old red phone boxes and placid streams. In Bonchester Bridge village mechanics pause to eat sandwiches with permanently blackened hands, leaving fingerprints on their foamy white bread. Soon, man gives way to nature. Trees cloak the valleys, organised legions of them like green ghosts of the old border armies. The clouds part and the sunshine licks them. This is the edge of Kielder Forest: over there, England.

Sheep part the way as we approach our first border frontier. There is no fence, no change in landscape or red line as on a map. This is the land of nature, and nature cares not a fig for the things man makes like borders. There is a gap between the signs declaring 'England' and 'Scotland', a no-man's land. England's declaration has stone grandeur (although someone has pen-knifed 'Sheffield' onto the St George Cross). Scotland's is functional and touristic, although it does 'Welcome You'. The countries share a long slither of meadow, a gentle, peaceful garnish on the land. Checkpoint Charlie it is not.

Our next frontier is Carter Bar, set gorgeously on top of a Cheviot hill. A coach empties a conveyor belt of tourists from Grimsby who are welcomed by a piper playing 'We Are Sailing' and then 'Wild Rover'. He has background percussion music and is selling CDs which boast: FOOT-TAPPING GUARANTEED. If borders must exist, they should all be as mad and jolly as this. They should all have a tacky, inappropriate soundtrack and a caravan selling bacon rolls, wine gums and paracetamol.

We find a long and forgotten valley foot road among the Cheviots. There is a stream here, a field of cheerful Asters there and in some parts trees lean over, a guard of honour. The sunny afternoon has turned hazy and dreamlike. We do not see another vehicle for miles, and no effort has been made to lure the tourist pound: the Still Lands are also Secret Lands, and they have come over all fairytale. It is no wonder that thousands of gypsies settled here from the 18th century onwards. It was too romantic for them not to. We pass through their spiritual home, Kirk Yetholm, with its Gypsy Palace. Outside here in 1898, thousands cheered the coronation of their

last gypsy monarch, King Charles Faa Blythe.

Their neighbouring village of Town Yetholm is, too, perfect enough to have been illustrated into existence for a children's book. There is a garden mob of gnomes and their friends, a world within a world, and men who have spent more days out than in spinning yarns over a dry stone wall. Passing thatched cottages and paths obscured by spindly wild flowers, we reach the village green. There is a newsagent, a butcher's and a pub. On the village noticeboard are two postcards – 'Walking poles found' and 'Bookshelf wanted'. A teenage couple sit silently in the wooden bus shelter. This place is perfect to

us, but there is nothing more boring than being young in a small village.

Inside the pub, we read an honours board celebrating winners of the yearly leek championships and file out to the beer garden. Our Scotland has come to an end. We reflect on all the Scotlands we have seen, each different to and as valid as the next. Each, even when downtrodden and left behind by economics and history, is alive with laughter, colour and possibility. No longer is this Edwin Muir's sad, emptying nation.

There is not really one Scotland we share, other than the one on paper. We do, though, share the many. Whatever the time and mood, they are a fine place to be.

153

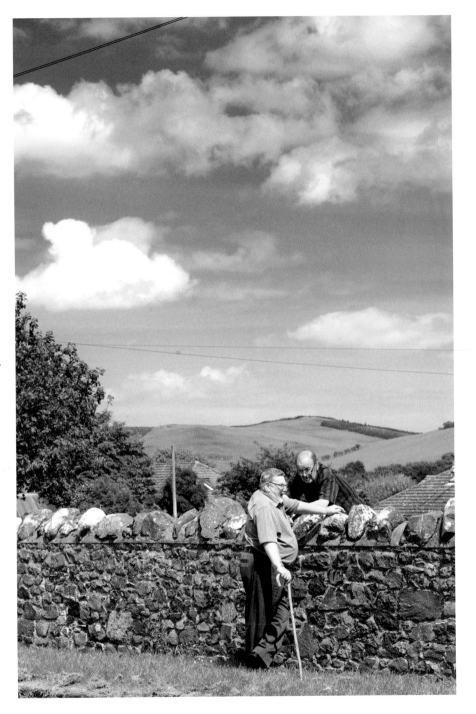

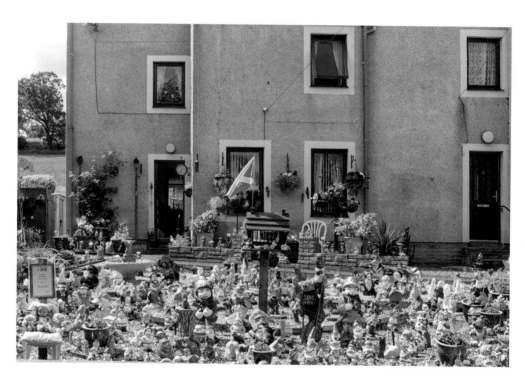

Homage to Caledonia: Scotland and the Spanish Civil War

Daniel Gray
ISBN: 978-1-90681-71-6 £9.99

Thirty-five thousand people from across the world volunteered to join the armed resistance in a war on fascism. More people, proportionately, went from Scotland than any other country, and the entire nation was gripped by the conflict. What drove so many ordinary Scots to volunteer in a foreign war?

Their stories are powerfully and honestly told, often in their own words: the ordinary men and women who made their way to Spain over the Pyrenees when the UK government banned anyone from going to support either side; the nurses and ambulance personnel who discovered for themselves the horrors of modern warfare; and the people back home who defied their poverty to give generously to the Spanish republican cause. Even in war, there are light-hearted moments: a Scottish volunteer drunkenly urinating in his general's boots, the dark comedy of volunteers learning to shoot with sticks amidst a scarcity of rifles, or enjoying the surreal experience of raising a dram with Errol Flynn. They went from all over the country: Glasgow, Edinburgh, Aberdeen, Dundee, Fife and the Highlands, and they fought to save Scotland, and the world, from the growing threat of fascism.

Daniel Gray has written a deeply human history, moving and thought-provoking, not only of those 549 people, but of two nations – Scotland and Spain – battling with an evil that would soon darken the whole of Europe.
THE HERALD

Important and powerful.
TONY BENN

Stramash! Tackling Scotland's Town's and Teams

Daniel Gray

ISBN: 978-1-906817-66-4 £9.99

Fatigued by bloated big-game football and bored of a samey big cities, Daniel Gray went in search of small-town Scotland and its teams. At the time when the Scottish club game is drifting towards its lowest ebb once more, *Stramash* singularly fails to wring its hands and address the state of the game, preferring instead to focus on Bobby Mann's waistline. Part travelogue, part history and part mistakenly spilling ketchup on the face of a small child, *Stramash* takes an uplifting look at the country's nether regions. Using the excuse of a match to visit places from Dumfries to Dingwall, Gray surveys Scotland's towns and teams in their present state. *Stramash* accomplishes the feats of visiting Dumfries without mentioning Robert Burns, being positive about Cumbernauld and linking Elgin City to Lenin. It is ae fond look at Scotland as you've never seen it before.

A brilliant way to rediscover Scotland.
THE HERALD

In another league.
THE SCOTSMAN

100 Weeks of Scotland:
A Portrait of a Nation in Transition
Alan McCredie
ISBN: 978-1-910021-60-6

100 Weeks of Scotland is a photographic journey – alongside thought provoking commentary – to discover the heart and soul of Scotland in the 100 weeks that led up to the independence referendum in September 2014.

From the signing of the Edinburgh Agreement through to the Referendum and its immediate aftermath, this is not a political book, but a book charting a country undergoing potential political change.

It examines Scotland in all its forms from its stunning landscapes to its urban sprawl and, most notably of all, through its people as they live their lives in the run up to the most significant democratic event in their country's history. It is a portrait of a nation in transition, a nation on the verge of the unknown.

Details of these and other books published by Luath Press can be found at:
www.luath.co.uk

Luath Press Limited

committed to publishing well written books worth reading

LUATH PRESS takes its name from Robert Burns, whose little collie Luath (*Gael.,* swift or nimble) tripped up Jean Armour at a wedding and gave him the chance to speak to the woman who was to be his wife and the abiding love of his life.

Burns called one of 'The Twa Dogs' Luath after Cuchullin's hunting dog in Ossian's *Fingal*. Luath Press was established in 1981 in the heart of Burns country, and now resides a few steps up the road from Burns' first lodgings on Edinburgh's Royal Mile.

Luath offers you distinctive writing with a hint of unexpected pleasures.

Most bookshops in the UK, the US, Canada, Australia, New Zealand and parts of Europe either carry our books in stock or can order them for you. To order direct from us, please send a £sterling cheque, postal order, international money order or your credit card details (number, address of cardholder and expiry date) to us at the address below. Please add post and packing as follows: UK – £1.00 per delivery address; overseas surface mail – £2.50 per delivery address; overseas airmail – £3.50 for the first book to each delivery address, plus £1.00 for each additional book by airmail to the same address. If your order is a gift, we will happily enclose your card or message at no extra charge.

ILLUSTRATION: IAN KELLAS

Luath Press Limited

543/2 Castlehill
The Royal Mile
Edinburgh EH1 2ND
Scotland

Telephone: 0131 225 4326 (24 hours)
email: sales@luath.co.uk
Website: www.luath.co.uk